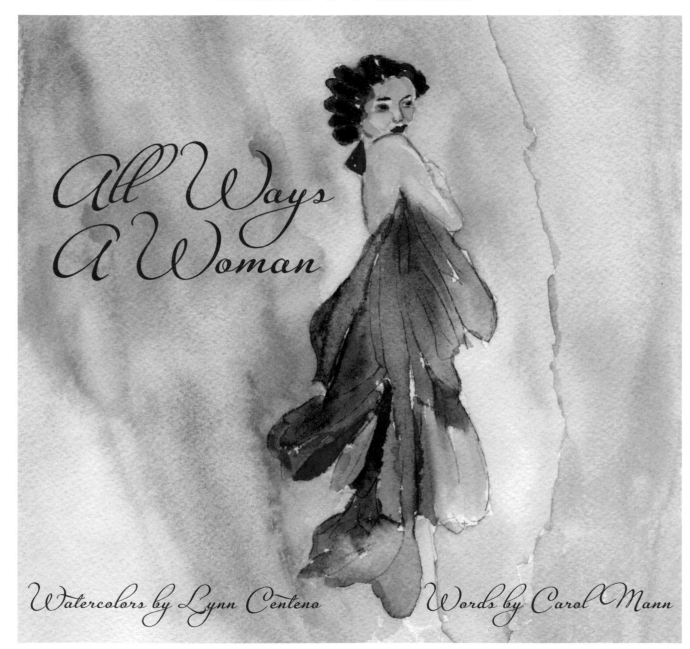

All Ways
A Woman

Watercolors by Lynn Centeno Words by Carol Mann

a celebration of

women

their thoughts, their loves, their lives

their dreams and desires

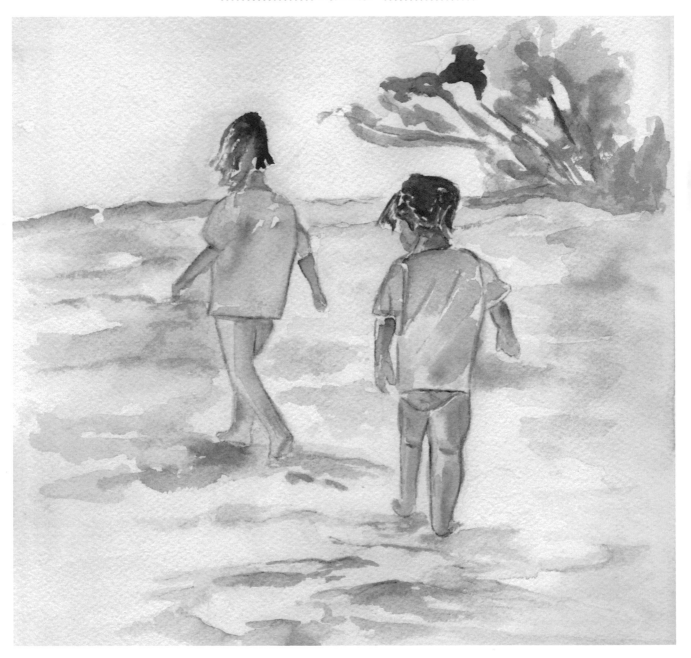

Come ...

walk with us

wonder

explore

For together

we grow

we discover

we become

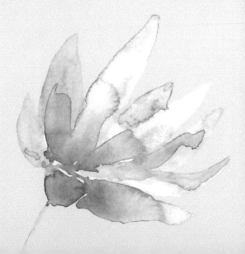

Reflections

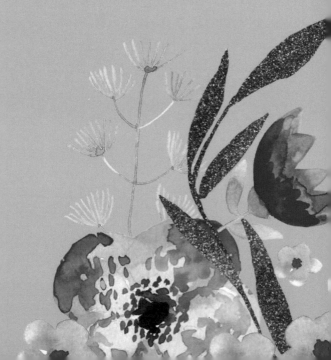

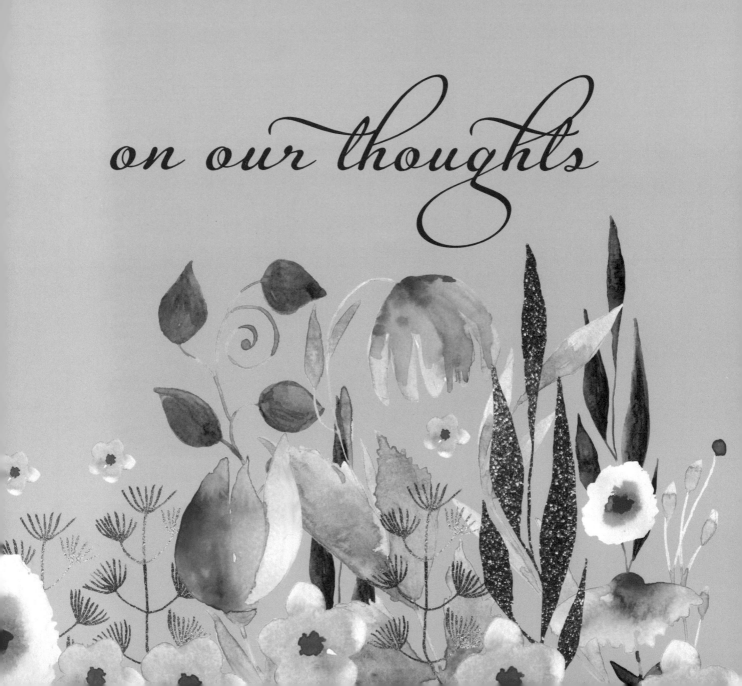

on our thoughts

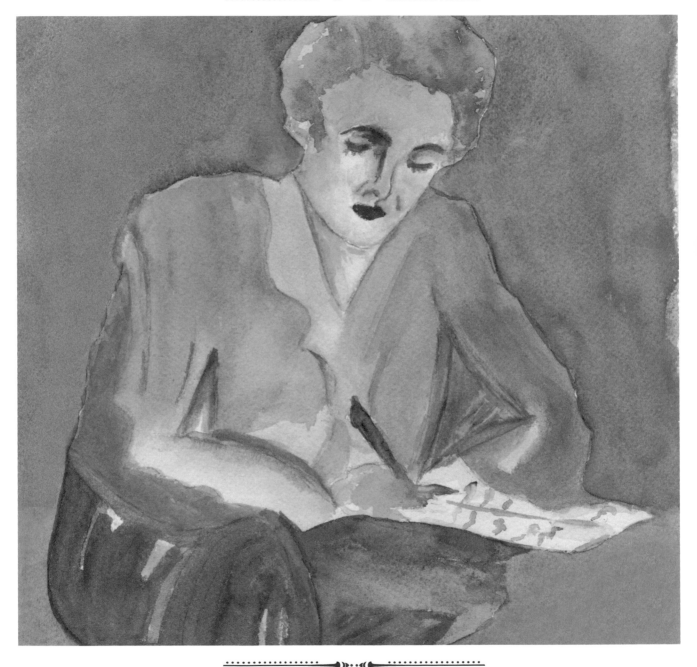

Within My Journal

Fragile as a budding flower,
thoughts arrive
on the arm of feelings.
Written words unfold
across the page, muses
for inner reflection.

I chronicle the hurt of a harsh word,
laughter bubbling from a sudden smile,
a lover's fingertips on my thigh,
the excitement of a child's first steps.

I note golden dawn arriving on tiptoe,
Indian summer's warm weather buffet,
the lingering scent of lavender lilacs,
a solitary stroll on an autumn's eve.

During quiet moments,
I wander life's gardens,
pen and paper my tools.
I write my words
to see what I think,
make sense of my world.

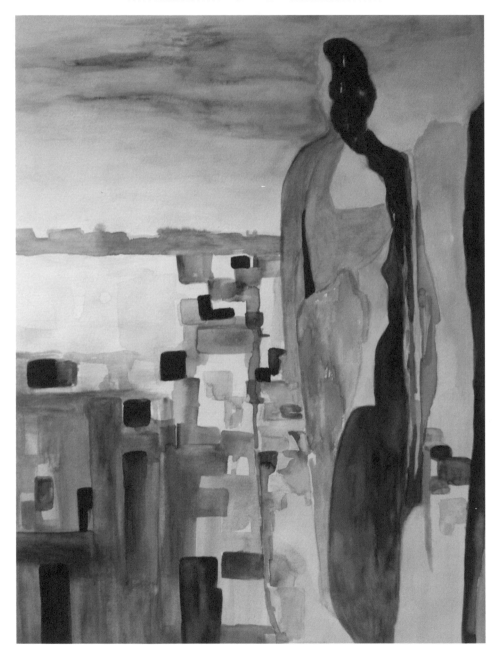

Voices

Tired sentences
 repeat in my head.
 "Stay inside the lines."
 "Don't step out of the box."

Negative self-talk
 undermines me.
 I challenge its prattle,
 shake away unwanted patterns.

My thoughts
 wait to be spoken.
 I release them
 from their closed boxes.

Into the milieu
 I step
 with dignity,
 with grace, with assurance.

My voice
 no longer whispers from shadow.

I am
 no longer a silhouette.

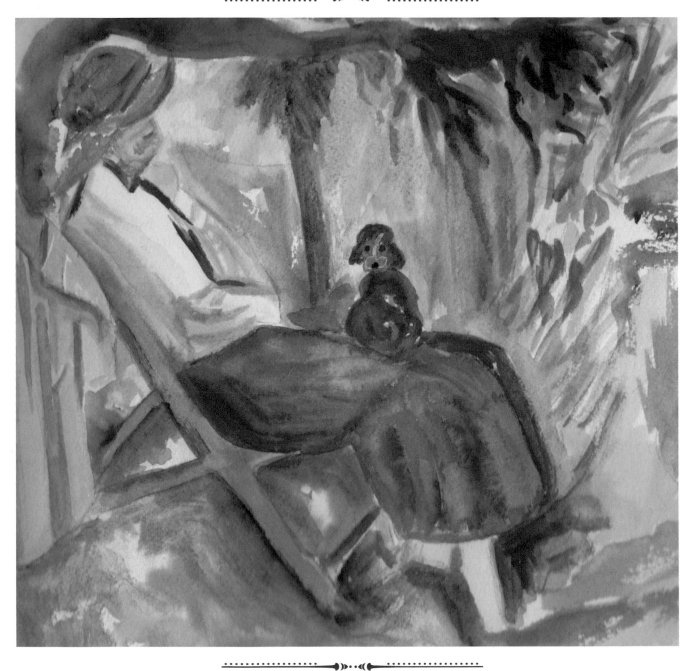

The Quiet Place

shards of uncertainty
pierce my subconscious
splinter thought

indecision
becomes doubt
doubt becomes fear

I waver

bewildered

unsure

until

I listen

intuition stirs an
inner voice
understanding unfolds

from this
quiet place within
I choose my path

wisely

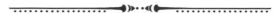

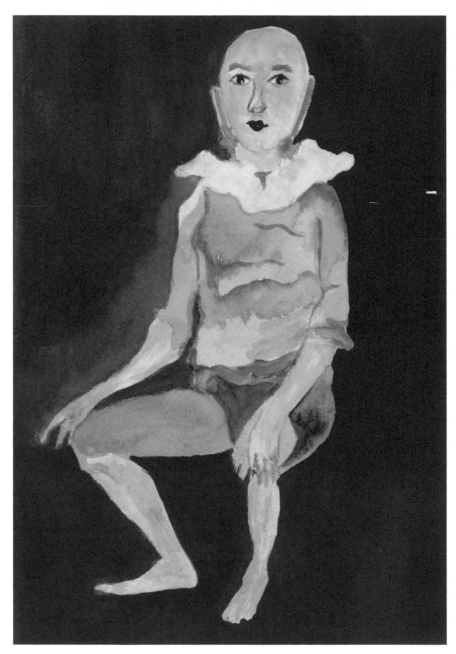

The Moment

Trickster time
cavorts around me,
a conjurer, giving false illusion
to hours squandered foolishly.
I drift, confused and lacking purpose.

Although new endeavors unfold,
sparks of excitement dwindle, fail
to ignite my spirit. Indifferent, empty,
I dabble, wander the periphery,
filling the days, but not my soul.

A moment must exist,
an interlude of unsuspecting time,
when I, unabsorbed and open,
devoid of my own concerns,
shall recognize my life's passion.

It will embrace me …
and I will know.

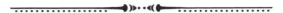

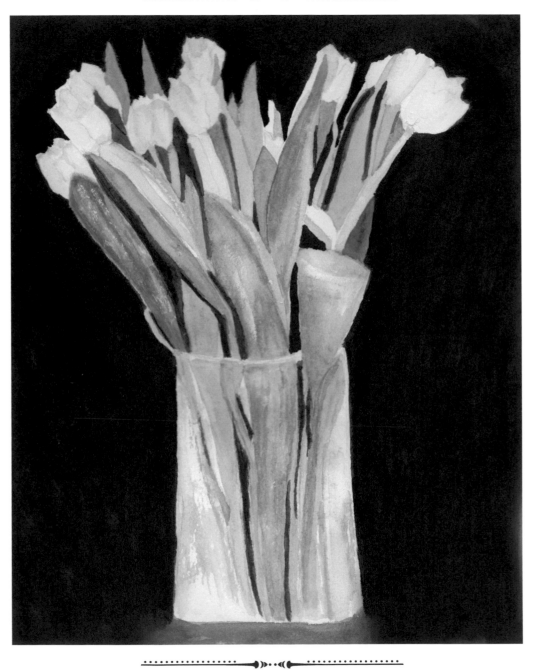

Suntlit Tulips

pieces of my life replay
a hoard
of tarnished thoughts and regrets

hurt dented
anger etched
washed by tears

unsettling memories
scratched by harsh words

I don't want them anymore
they molder in the past
keep me from the moment

sully the smile
of sunlit tulips white
bowing gently

from a clear glass vase

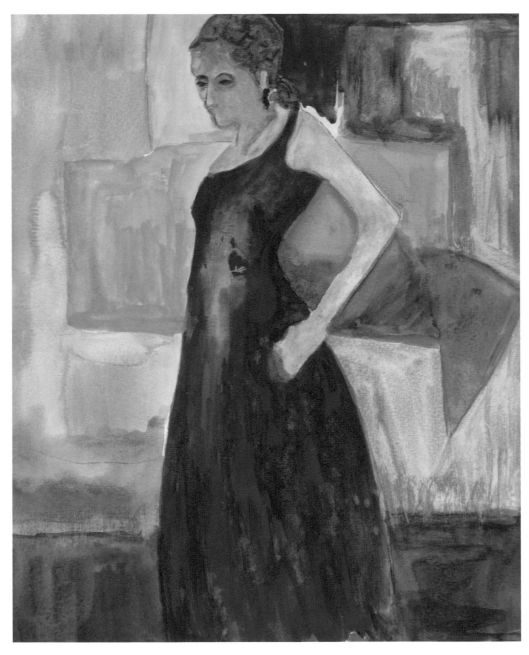

What am I?

I am a treble clef
 filled with bright song
 curled around harmony
 occasional discord

I am a flamenco step
 heeled boot
 stomping insecurity to the ground
 whirling confidence

I am a song
 peeking on tiptoe
 whispering lyric
 bursting to melody

I am a genie's lamp
 wishes I fulfill
 my own desires
 can come true

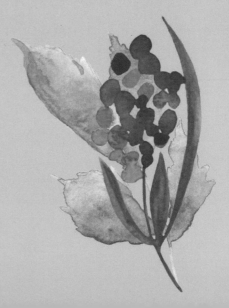

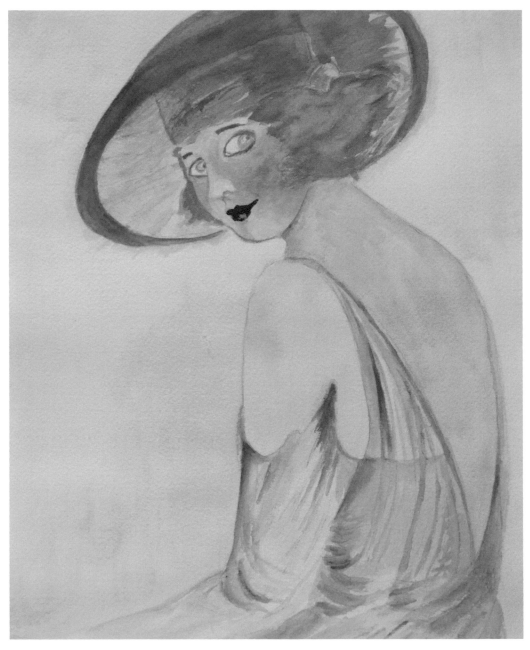

Always a Bridesmaid

Gowned and demure,
 she smiles,
 she beguiles.

With a voice like
 soft music,
 over her shoulder
 she speaks.

"Always a bridesmaid?
 Never a bride?
 My day will come?
 Wait, that is for me
 to decide.
 My star I guide,
 the future to fulfill mine."

Gowned and demure,
 she smiles,
 she beguiles.

Unabashed eyes
 reveal her thoughts,
 unveil her feelings,
 bespeak her spirit.

Reflections

on our loves

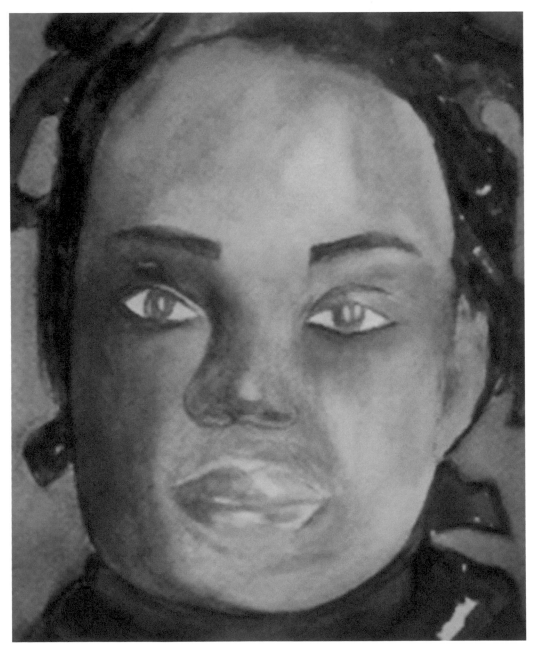

I Care Not

"I care not," you say.
A flippant toss of your head
accompanies the banter from your lips.

As I listen, subtle signs undo you.
A sigh, a slight defeat in your stance,
an awkward gesture, an unwitting shrug.

Your heart steals truth
from your words.
Brave vows fail to
illuminate once vibrant eyes.

A steady gaze
dulled by last night's tears
cannot undo his broken promises.

"I care not," you say again.
Perhaps this may soon be true but
today ... now ... your eyes speak your hurt.

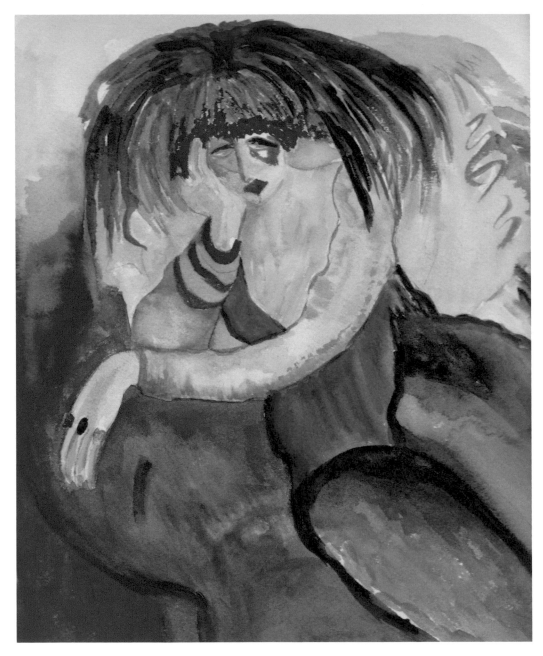

A Villanelle

Song of the Cabaret Chanteuse

Like a wanton blues note lingers long,
knowing not a time to fade away,
a sad chanteuse sings her soulful song.

Standing worldly, carefree, to the throng,
inner hurt cuts deep in life once gay,
like a wanton blues note lingers long.

Vows untrue rang false, the music wrong.
Cool embraces told her not to stay.
A sad chanteuse sings her soulful song.

Her body lay in silken sarong
beside him yearning to love, to play,
like a wanton blues note lingers long.

His dispassion stabbed, piercing and strong.
"Leave," she heard him without feeling say.
A sad chanteuse sings her soulful song.

Pulsing sorrow finds a lonely dawn.
Lost, the joy of passion's sweetest day.
Like a wanton blues note lingers long,
a sad chanteuse sings her soulful song.

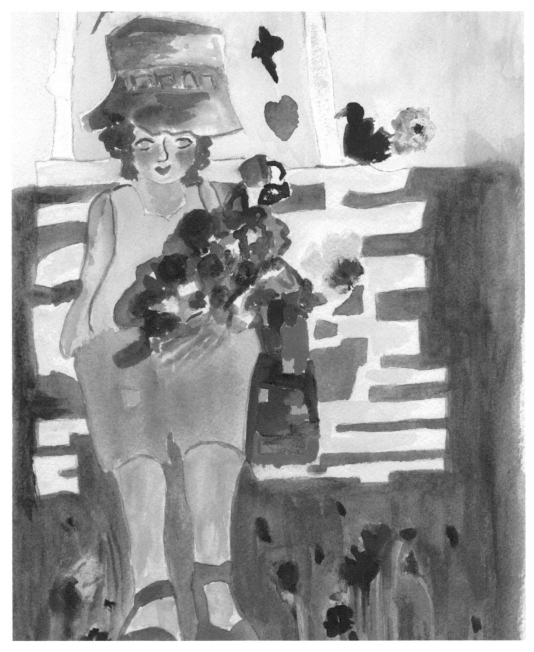

Raggedy Ann's Lament

Sitting alone on a garden bench white,
dejected, uncaring for life all around,
Raggedy Ann reflects upon her plight.
 Dear Andy's love no longer abounds.

Sad thoughts fill her head, she feels so low.
Of her, she thought, he never would tire.
Ann mulls the loss of her storybook beau.
 Never more will Andy sit beside her.

A once happy smile is now down-turned,
tears slip away from very sad eyes.
Alas, Raggedy Ann a life lesson has learned.
Some men do disdain long permanent ties.

Andy is gone, no longer to appear.
Ann promises not to collapse nor fall,
she won't lament or shed endless tears.
 Alone she will stand, confident and tall.

Her expression changes into resolve,
sweet lips again find an upturned smile.
Ann's faith in men and love is strong.
 Others will appear for her to beguile.

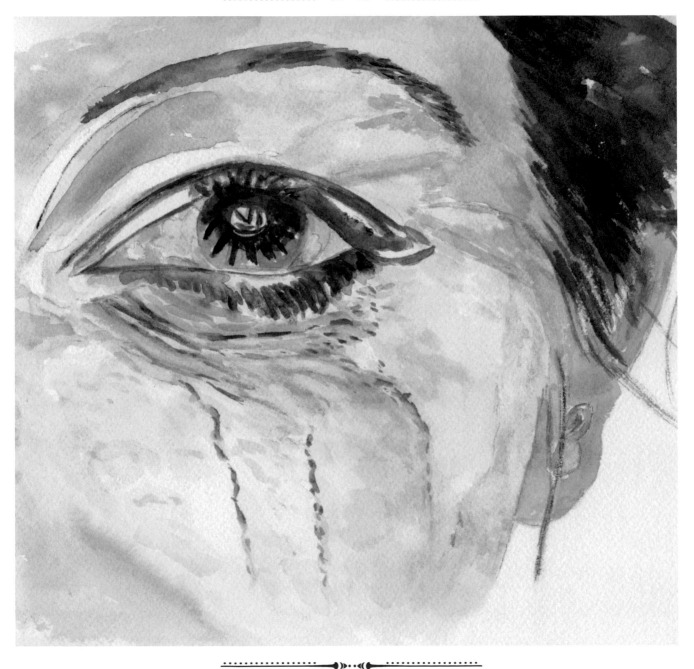

Moonlight

A full moon's light

 brushes my room,

 nestles in corners,

 strokes my sadness

 with shadow.

I lie in moon-glow,

 alone, not wanting

 my gloom nor

 the echo of emptiness

 around me.

Your moonlight caress

 was once mine,

 but only tears

 touch me tonight,

 only tears and the moon.

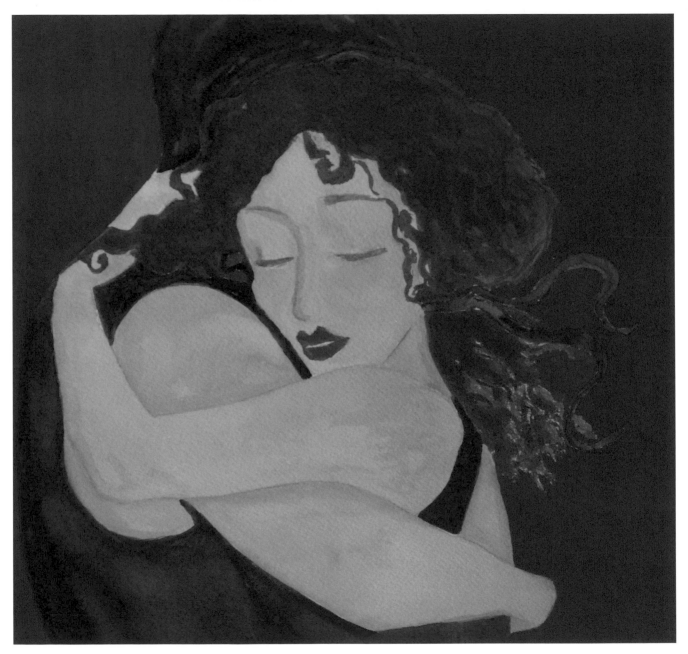

Quartet

clouds drape the mountains

hide them in a winter's snow

I'm safe in your arms

fragile hummingbirds

linger by budding flowers

I bloom with your kiss

springtime slips away

a summer sun warms the dawn

you illume my life

leaves turn in color

fall to the ground, fade away

constant is our love

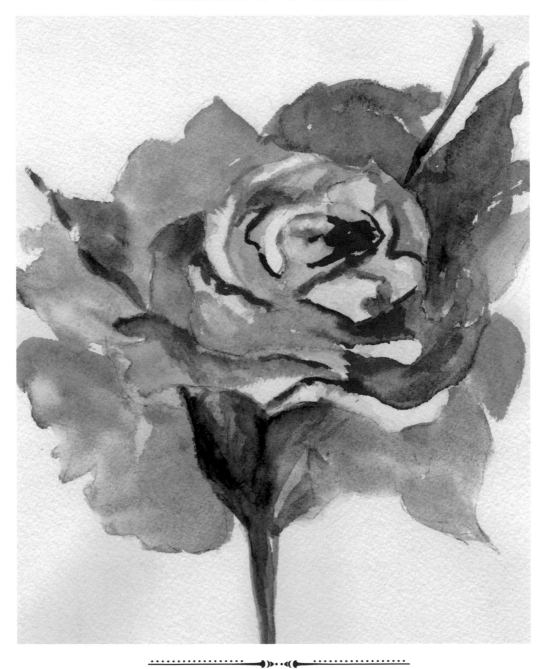

The Rose

Early dew shimmers within the folds
of a fragile bloom. Soft petals unfurl,
warmed by the sun,
cradled by light.

I cup the flower between my palms,
savor the scent, recall the lure
of our young love. It too
blossomed and grew.

But now I'm alone, the evening of age
upon me. I linger in the garden
by your favorite rose.
It comforts me.

Reflections

on our lives

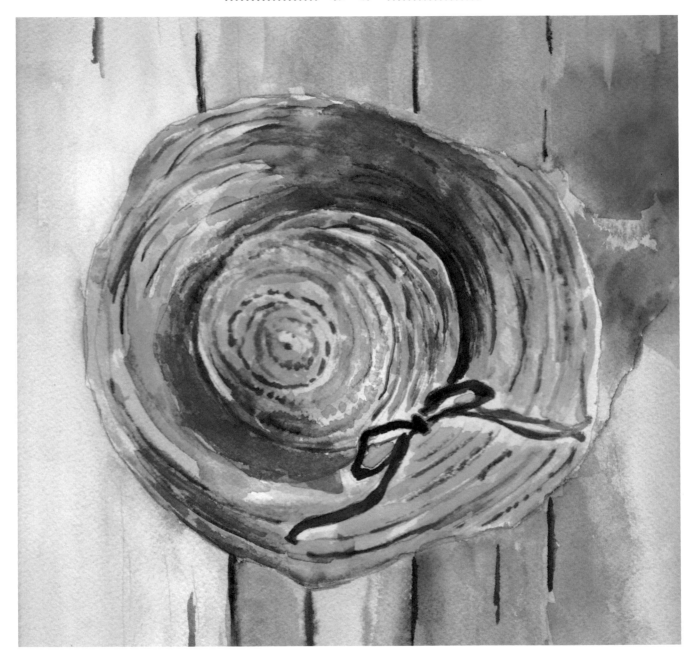

My Mother's Hat

My mother's hat is woven of straw,

a worn and weathered circle

of complicated love.

Its presence

recalls her special gifts to me.

Choices—rainbowed with dreams.

My mother's hat shields from summer's sun,

a wide-brimmed haven

of sacrifice and constancy.

Wearing it

brings her memory close.

I hear her words, feel her near me.

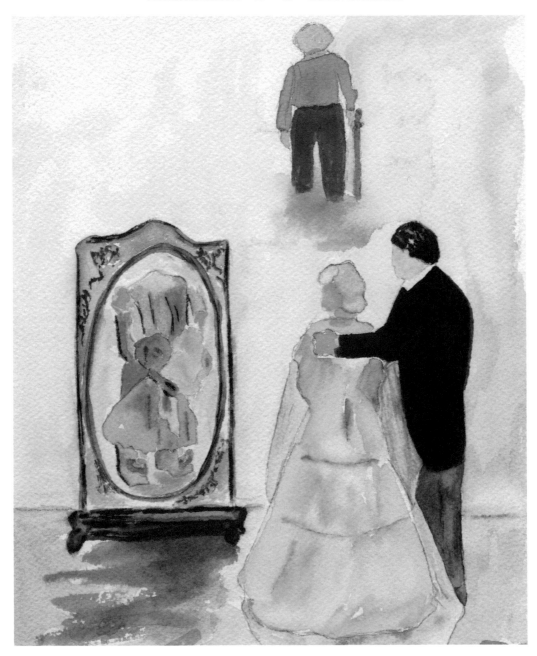

A Walk with Her Father

She puts her small hands
in his, unsure. She wobbles.
Gently, he steadies her.
They glide across the
room, her steps upon his.
Her first dance.

She slips her arm in his.
From behind a white veil
she smiles at him.
They begin their walk
down the carpeted aisle.

"Who gives this woman?"
"I do," he answers. She
feels the squeeze of his
hand as she steps away
to join her husband-to-be.

She takes her father's hand.
They walk beneath the maples,
their fingers entwined.
His cane taps the sidewalk,
leaves crunch underfoot.
She steadies him with each step.

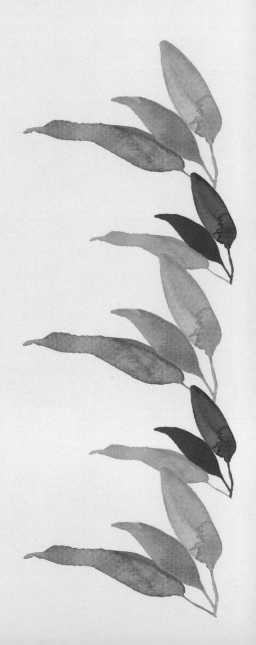

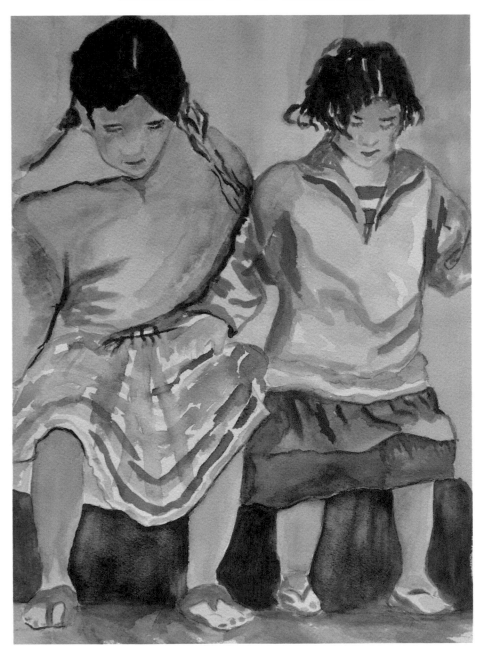

At the Wading Pool

idle feet swish back and forth,
 make wavelets play on a summer's day

 paintbrush toes swirl to and fro,
 sweep ripples into watercolor imaginings

 ribbons dance, flower petals unfurl,
 foamy clouds billow, gemstones flicker

 pink nail polished toes glisten like
 rose garnets under sun-kissed water

 blue painted toes shimmer,
 tiny sapphires beneath gossamer glass

 images languish, colorful and carefree,
 float away on gentle swells

on a Sunday afternoon sisters dance an
 art ballet at the wading pool

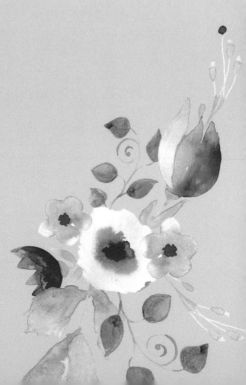

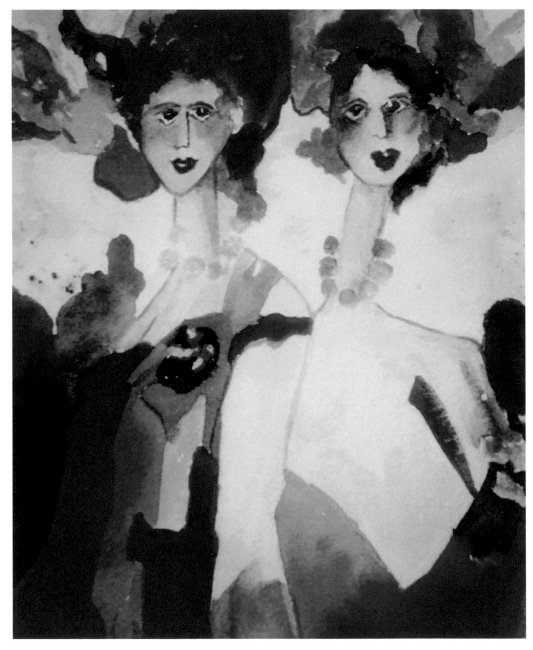

friends ...

with walks of life down different paths
they didn't plan to bond
but books and art
their hands did join
with poetry and color

their hands did join
in laughter
with martini smooth
and double olive

their hands did join
over coffee dark
to speak of
news and being

their hands did join
to share each
other's greatest joys
or sadness

with walks of life down different paths
they didn't plan to bond
but friends they became
to search for truth
create with words and image

friends ...

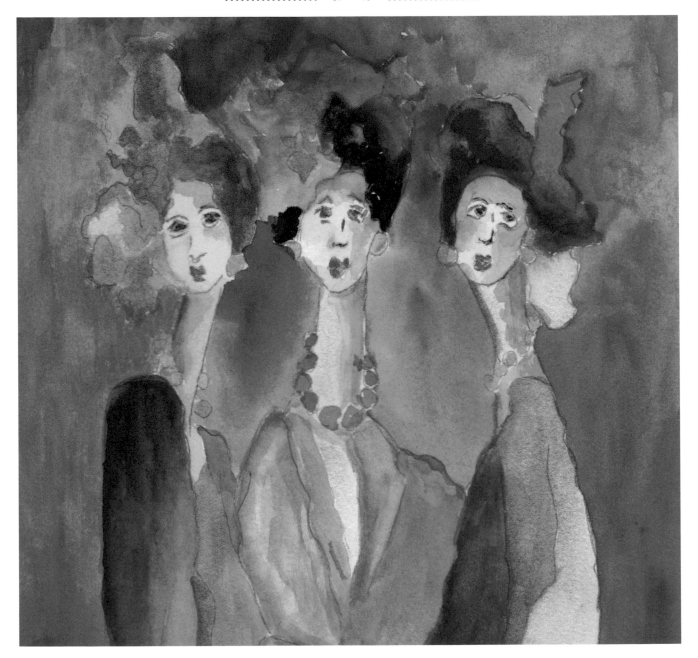

Girls' Night Out

"Do you see what I see?
Is it him or is it me?
The tall one sitting next table over
is giving me the eye. Oh, he's a Rover,"
 said the girlfriend with the blue chapeau.

"Do you see what I see?
Oh, my, can it really be?
That's Ingrid's husband with a tart.
When did that affair start?"
 said the girlfriend wearing her hat of orange.

"Do you see what I see?
Carla's divorce has set her free.
Now she's busy cougaring here.
The boy's not dry behind the ear,"
 said the girlfriend under an aqua plume.

The girlfriends never miss this night
of shock, of awe, and sheer delight,
to dish, to sip their chardonnay
and savor an evening of delicious play.

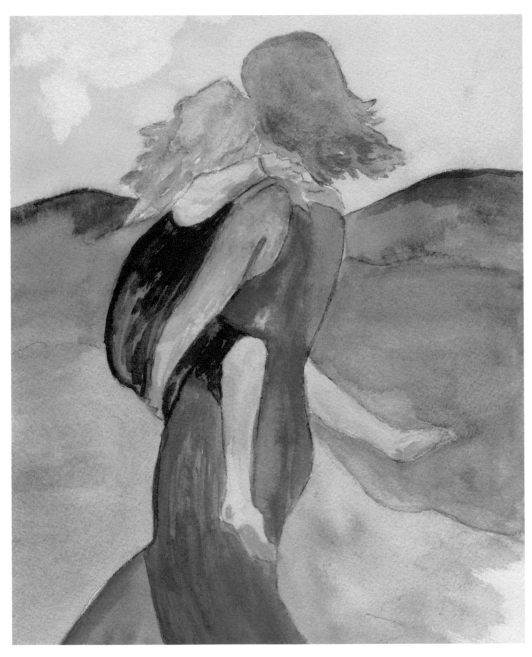

In My Arms

My precious little girl,

your every breath

takes mine away.

Forever I remember the first time

I held you, the moment we became

mother and daughter.

Know always I'm here,

your soft cloud, your safe

haven in life.

I savor your sweet

innocence, the beating

of your heart against mine.

"Mommy," I hear as you snuggle close.

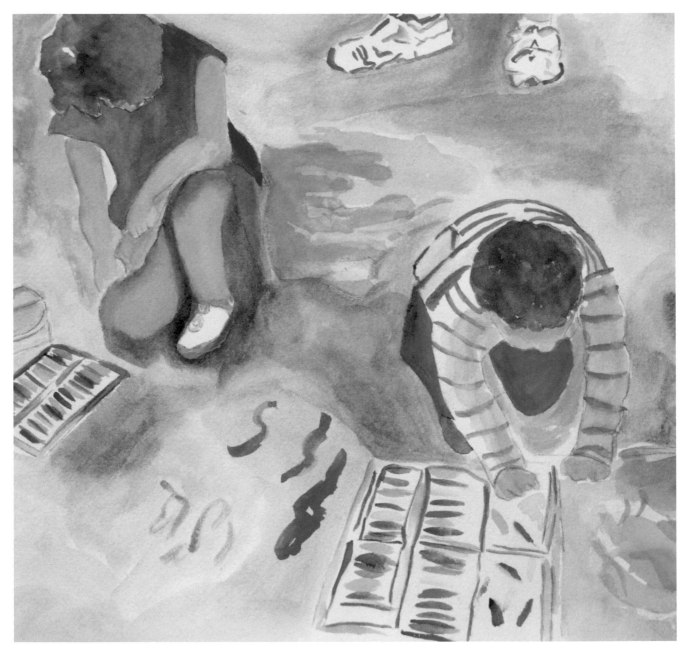

White Paper

blue paint dollops and green
 spread
 slick on
 paper
 pristine

fingers slide across the sleekness
 swish backward
 wiggle forward
 whirl in circles
 twist and twirl

ocean waves curl
 become rugged peaks
 meld to a monster's face
 blossom into
 a giant rayed sun

a smile lights my little boy's face
 smudges
 of finger paint
 decorate
 his cheek, his nose

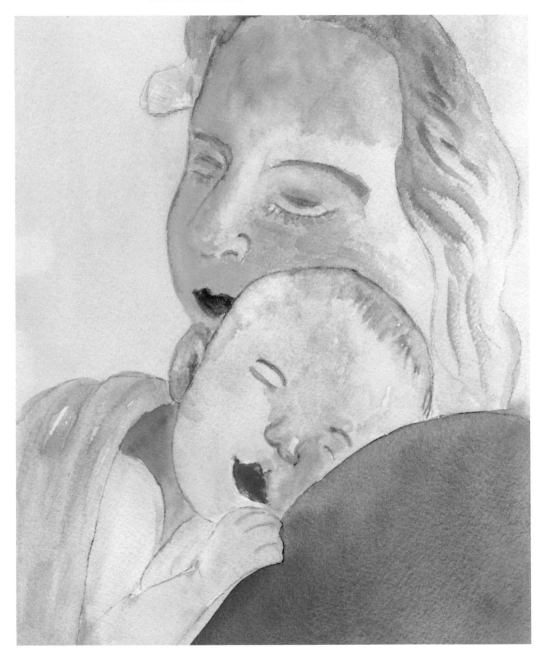

Life Song

Softly, I say hello
to the baby grandchild
held before me.
My aging hands
cradle the child's feet,
soft with inexperience.

You'll begin with small steps, I murmur.
Big strides will follow.
Life's path may be uneven
but your legs push
hard into my palms and
I know you are strong.

Small fingers uncurl and
stretch toward me.
Pink toes wriggle.
I take the child
into my arms, the autumn
of life again bright spring.

Do you feel it, little one? I whisper.
Your wonder, my joy
forever joined? My heart soars
with wishes, with dreams.
I wish you fulfillment,
I wish you love.

I wish you a life song filled with beauty.

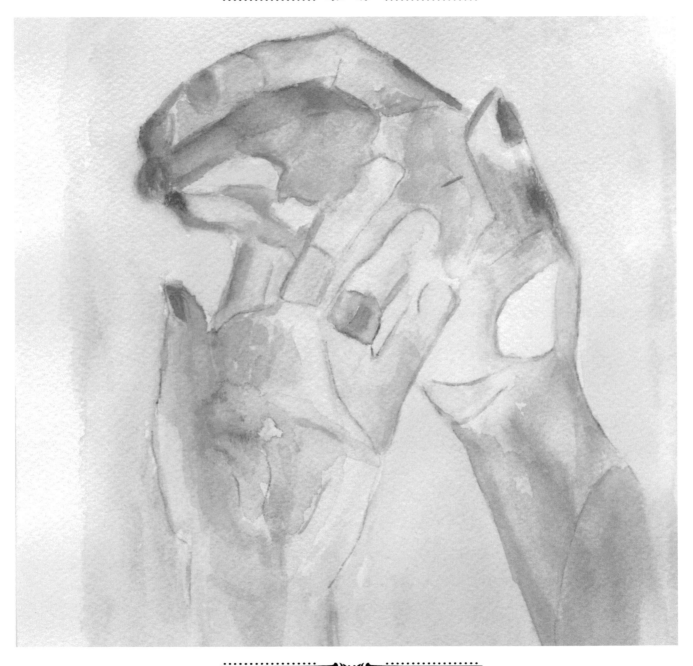

A Woman's Hands

On her slender fingers rare gemstones glisten,
 wisdom mined from experience,
 expertise polished by time,
 talent of many facets,
 skills clear and true.

Her every touch, gentle and caring, enfolds
 a lover's caress,
 children soft with innocence,
 cherished friends,
 fragile palms of elders.

In her hands come gifts of countless shapes and sizes
 boxes labeled love,
 baskets filled with wishes,
 bundles of care and constancy,
 cartons of life's trinkets.

A woman's hands

Our hands

All Ways

A Woman

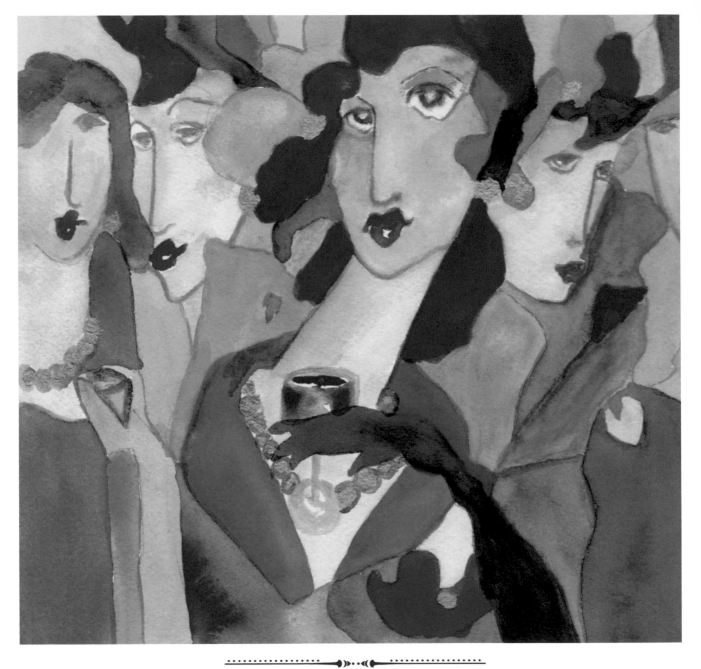

The Gift of the Gathering

together we gather
joyous, worried
contemplative
optimistic, stoic, sad
our world view guides our thought
our life experience bonds us
our roles are many

we are daughters
our mothers' students
apprentices of daily life
explorers beyond its bounds

we are sisters
first playmates
rivals yet confidants
safe havens for secrets

we are wives
joined in ceremony
partners through life's
trials and uncertainties

we are girlfriends
pillars for each other
amid coffee meets
shopping trips and emails

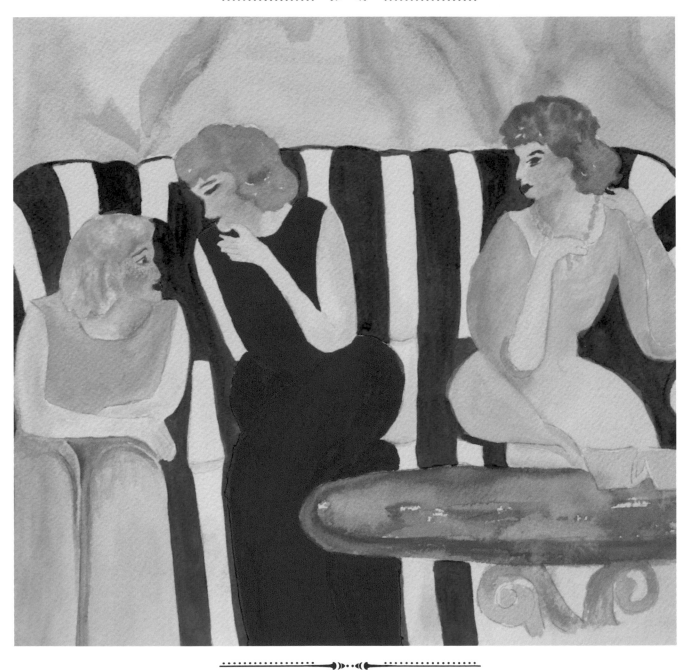

we are mothers
bearers of children
nurturers of body and soul
daily crisis solvers

we are grandmothers
keepers of the family story
protectors of tradition
custodians of keepsakes

we are teachers
stewards of society's values
perpetuators of culture
art, music, the written word

we are trailblazers
challengers of laws
openers of doors
ceiling breakers

we are talents
heroes for young girls
making our marks
in the avenues of the world

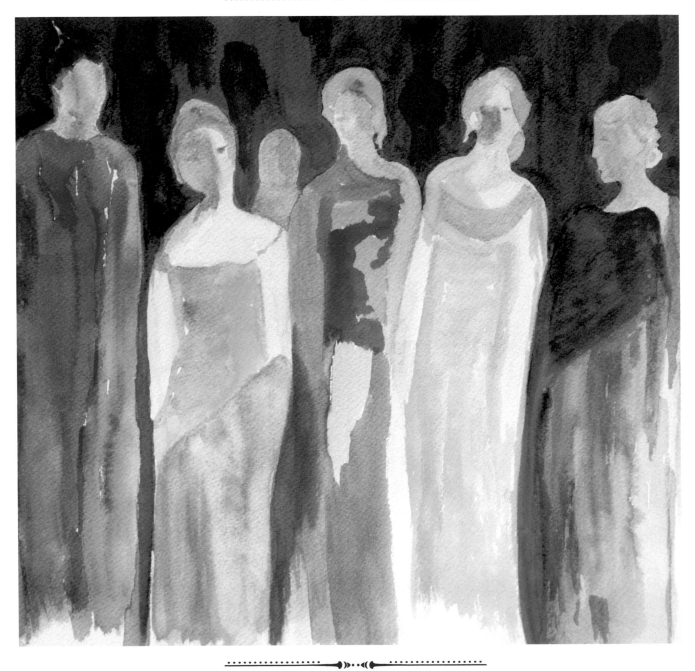

foremost

we are women

governors of our own destiny

constant, ever evolving

pioneers for the next generation

we lead our lives

we renew during moments of inner peace

 cope through times of turmoil

 encounter illness and misfortune

 weep with sadness

 celebrate with joy

we discover ways to go on

all ways a woman

and always

we grow stronger together

the gift of the gathering is ours

Biographies

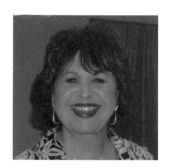

Lynn Centeno is a fine arts watercolorist. She was recently in a juried exhibition called "Creativity Take Two" at the La Quinta Museum. Lynn is the co-founder of "Outside the Lines," an arts based support group for women. Her art has been displayed at Sm'Art Gallery in La Quinta, CA. Lynn's newest show is "Women in Art" also at the La Quinta Museum. She holds a Bachelor's of Science in History and a Master's in Education from the University of Southern California. One of her favorite quotes from Pablo Picasso is, "Art washes away from the soul the dust of everyday life."

Carol Mann is a published author. Her short stories, poetry, and personal essays have appeared in literary journals and magazines such as *Six Hens, Bloodroot, RiverSedge, Dual Coast Magazine,* and *The Sun Runner.* Thoughts on writing and life can be found on her blog "Written Beneath the Palms." Carol holds a B.S. in Education from SUNY Buffalo and an M.A. in Theatre from CSU Fullerton. It was, she discovered, both a pleasure and a challenge to brush words onto the portrait of a woman, onto her many layers, her many roles, her sorrows, and her joys.

Printed in the United States of America
First Edition 2017

ISBN 978-0-9905827-7-9

Library of Congress Control Number: 2016960294

Published by
AquaZebra
35070 Maria Road
Cathedral City, CA 92234
www.AquaZebra.com

AquaZebra™

Book Design, Layout, and Publishing

CPSIA information can be obtained at www.ICGtesting.com
Printed in the USA
LVIW01n2322291216
519196LV00002B/2